NICOTEXT

90 Classic Books for People in a Hurry

by
Henrik Lange

Original title: 80 romaner för dig som har bråttom (2007)
This book is an adaptation of the original.

Illustrations: Henrik Lange
Text: Henrik Lange, Thomas Wengelewski

Copyright © NICOTEXT 2009 All rights reserved.
NICOTEXT part of Cladd media ltd.
www.nicotext.com
info@nicotext.com

Printed in the USA
ISBN: 978-91-85869-29-9

Tick for books I've read

- ☐ The Da Vinci Code
- ☐ Lord of the Rings
- ☐ Heart of Darkness
- ☐ The Old Man and the Sea
- ☐ The Chronicles of Narnia: The Lion, the Witch and the Wardrobe
- ☐ Lord of the Flies
- ☐ The War of the Worlds
- ☐ Nineteen Eighty-Four
- ☐ Moby-Dick
- ☐ The Trial
- ☐ The Bible
- ☐ Crime and Punishment
- ☐ The Ingenious Hidalgo Don Quixote of La Mancha
- ☐ Twenty Thousand Leagues Under the Sea
- ☐ Treasure Island
- ☐ The Picture of Dorian Gray
- ☐ The Adventures of Tom Sawyer
- ☐ The Name of the Rose
- ☐ Death in Venice
- ☐ Lolita
- ☐ Catch-22
- ☐ Odyssey
- ☐ The Call of the Wild
- ☐ Smilla's Sense of Snow
- ☐ Watership Down
- ☐ Life of Pi
- ☐ Naked Lunch
- ☐ Alice's Adventures in Wonderland
- ☐ Nausea
- ☐ Boule de Suif
- ☐ And Then There Were None
- ☐ A Clockwork Orange
- ☐ The Hunchback of Notre Dame
- ☐ Three Men in a Boat
- ☐ Of Mice and Men
- ☐ On the Road
- ☐ The Master and Margarita
- ☐ The Catcher in the Rye
- ☐ Ulysses
- ☐ All Quiet on the Western Front
- ☐ The Tell-Tale Heart
- ☐ Das Boot
- ☐ First Blood
- ☐ The Shadow of the Wind
- ☐ Watchmen

- ☐ The Alchemist
- ☐ One Flew Over the Cuckoo's Nest
- ☐ Gulliver's Travels
- ☐ Thérèse Raquin
- ☐ The No. 1 Ladies' Detective Agency
- ☐ Perfume: The Story of a Murderer
- ☐ Our Man in Havana
- ☐ Pet Sematary
- ☐ Charlie and the Chocolate Factory
- ☐ The Hitchhiker's Guide to the Galaxy
- ☐ Romeo and Juliet
- ☐ The Stranger
- ☐ Frankenstein
- ☐ Fahrenheit 451
- ☐ Robinson Crusoe
- ☐ American Psycho
- ☐ The Hound of the Baskervilles
- ☐ Brave New World
- ☐ Steppenwolf
- ☐ Uncle Tom's Cabin
- ☐ A Confederacy of Dunces
- ☐ One Hundred Years of Solitude
- ☐ Factotum
- ☐ The Great Gatsby
- ☐ Pride and Prejudice
- ☐ A Passage to India
- ☐ The Naked and the Dead
- ☐ Dracula
- ☐ 2001: A Space Odyssey
- ☐ The Three Musketeers
- ☐ Oliver Twist
- ☐ In Search of Lost Time
- ☐ Hunger
- ☐ City of Glass
- ☐ The Golden Notebook
- ☐ Black Water
- ☐ The Big Sleep
- ☐ To Kill a Mockingbird
- ☐ Death of a Salesman
- ☐ The Beach
- ☐ The Thorn Birds
- ☐ The Clan of the Cave Bear
- ☐ The Spy Who Came in from the Cold
- ☐ I Am Legend
- ☐ The Piano Player

American Psycho, 1991
Bret Easton Ellis, 1964–

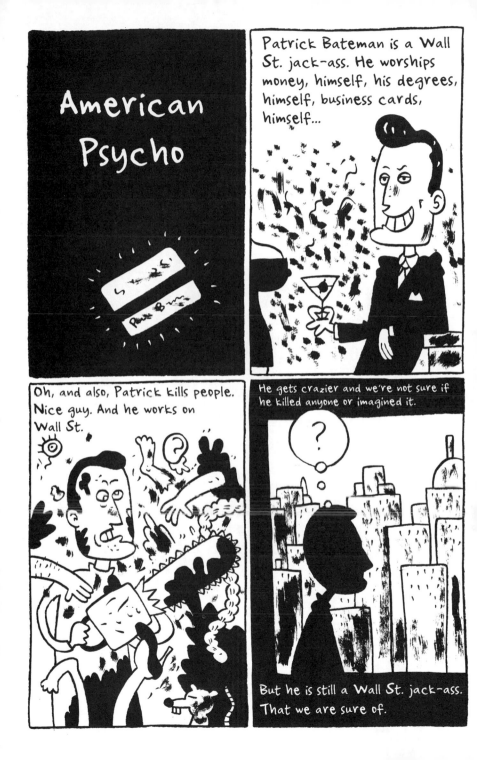

A Passage to India, 1924
E. M. Forster, 1879-1970

A Passage to India

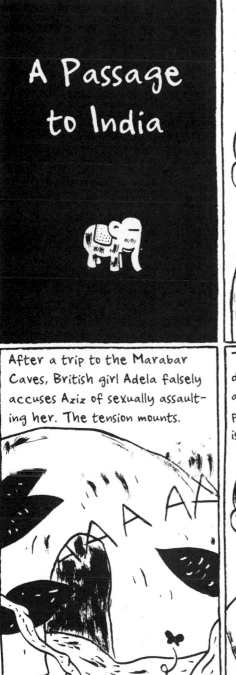

Cyril Fielding and Dr. Aziz are chums in India even though one is a Brit and the other Indian.

After a trip to the Marabar Caves, British girl Adela falsely accuses Aziz of sexually assaulting her. The tension mounts.

AAA AA

The charges against Aziz are dropped but Cyril and Aziz aren't friends anymore and probably won't be until India is free.

The Beach, 1996
Alex Garland, 1970-

The Beach

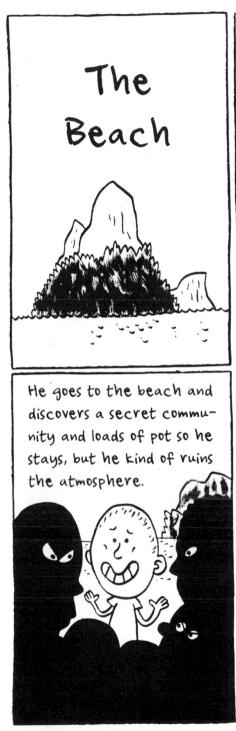

Richard is given a map of a secret beach near Thailand where they have loads of pot.

He goes to the beach and discovers a secret community and loads of pot so he stays, but he kind of ruins the atmosphere.

Despite the copious ganja the community gets violent and kills people. Richard flees the island in search of safety and munchies back in England.

The Big Sleep, 1939
Raymond Chandler, 1888-1959

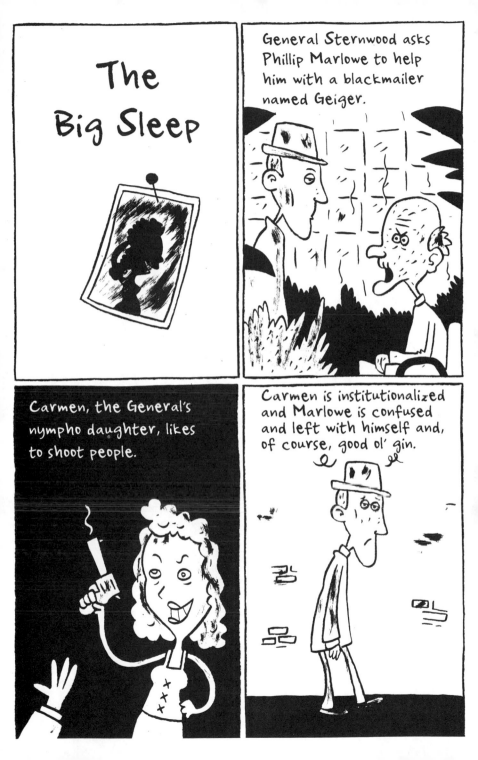

Black Water, 1992
Joyce Carol Oates, 1938–

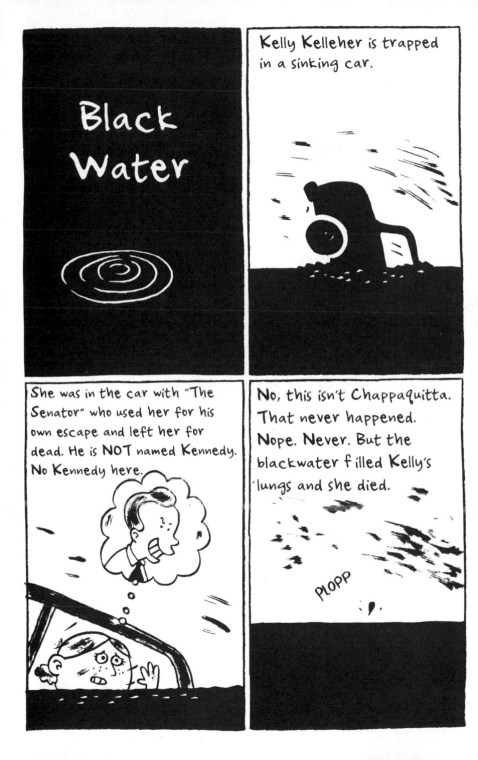

Brave New World, 1932
Aldous Huxley, 1894-1963

Brave New World

Bernard and Lenina go on vacation to Savage Island and meet John — a savage. They take him home to the World State for kicks.

Back in the World State John is the life of the party and people down soma, a state hallucinogen, like there's no tomorrow.

But John, addicted to soma, kills himself out of shame. Say no to soma!!!

The Clan of the Cave Bear, 1980
Jean M. Auel, 1936-

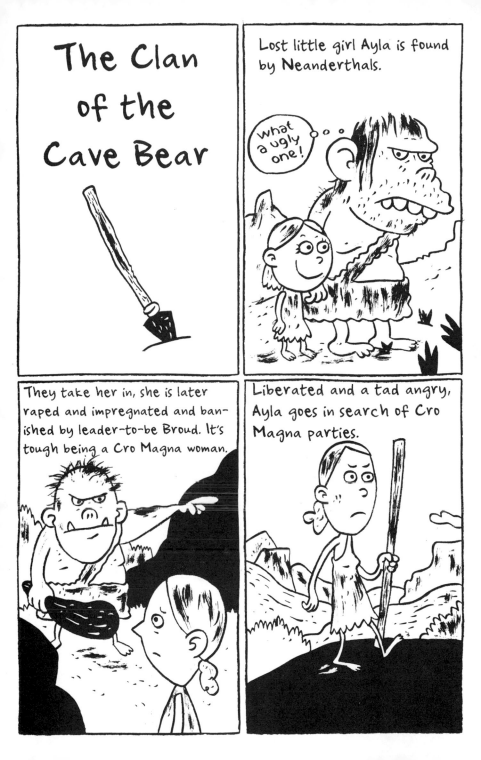

City of Glass, 1987
Paul Auster, 1947-

City of Glass

Daniel Quinn answers the phone which is somebody looking for detective Paul Auster.

Daniel takes on the case acting as a detective. He is asked to follow crazy language dude, Peter Stillman Sr. who is trying to kill his son.

Daniel, or Paul if you like, looses track of Stillman and eventually also looses his apartment.

A Confederacy of Dunces, 1980
John Kennedy Toole, 1937-1969

A Confederacy of Dunces

Ignatius Reilly is 30, doesn't work, and lives with his mom in New Orleans. He also wears funny hats. In New Orleans he is pretty normal.

His mom forces him to get a damn job, including selling hot dogs in the French Quarter. He gets fired from them all.

Like most people from the French Quarter he is threatened to be committed to an asylum but escapes with his ex-girlfriend to New York.

NEW YORK

Death of a Salesman, 1949
Arthur Miller, 1915-2005

Death of a Salesman

William Loman is an old salesman that never got past mediocrity.

He gets fired from his job. Now he is an old ex-salesman whose sons, Biff and Happy, think he is a loser. With names like that can you blame them?

So he offs himself.

Dracula, 1897
Bram Stoker, 1847-1912

Dracula

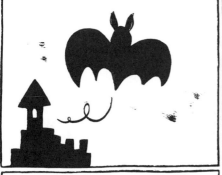

Jonathon Harker is sent to Transylvania for a business deal with Dracula. He is locked up but eventually escapes Dracula's castle.

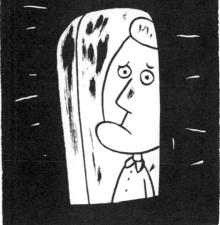

Dracula makes his way to London to woo Mina, Harker's fiancé, and turns the town upside down. Harker and crazy scientist Van Helsing chase Dracula back to Transylvania and kill him.

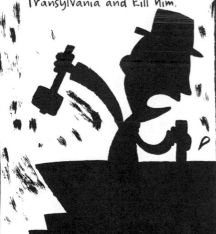

Harker and Mina are married and have a pointy tooth little baby. Perhaps Mina has some explaining to do.

Fahrenheit 451, 1953
Ray Bradbury, 1920-

Fahrenheit 451

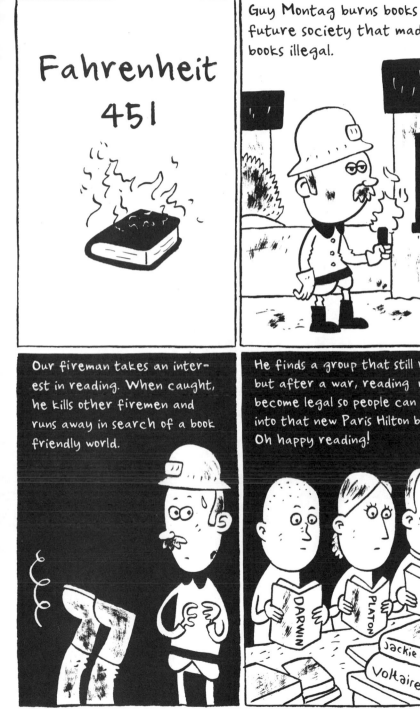

Guy Montag burns books in a future society that made all books illegal.

Our fireman takes an interest in reading. When caught, he kills other firemen and runs away in search of a book friendly world.

He finds a group that still reads but after a war, reading might become legal so people can dive into that new Paris Hilton book. Oh happy reading!

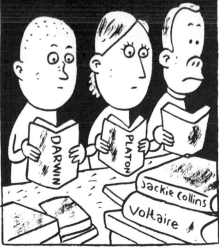

First Blood, 1972
David Morrell, 1943-

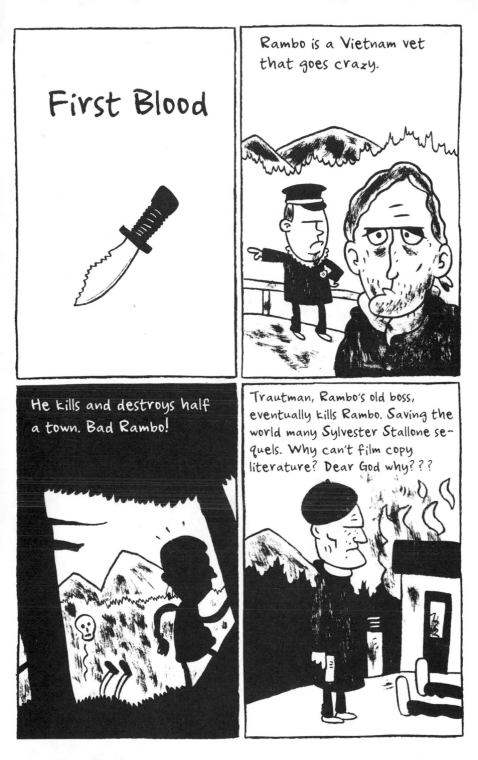

The Golden Notebook, 1962
Doris Lessing, 1919-

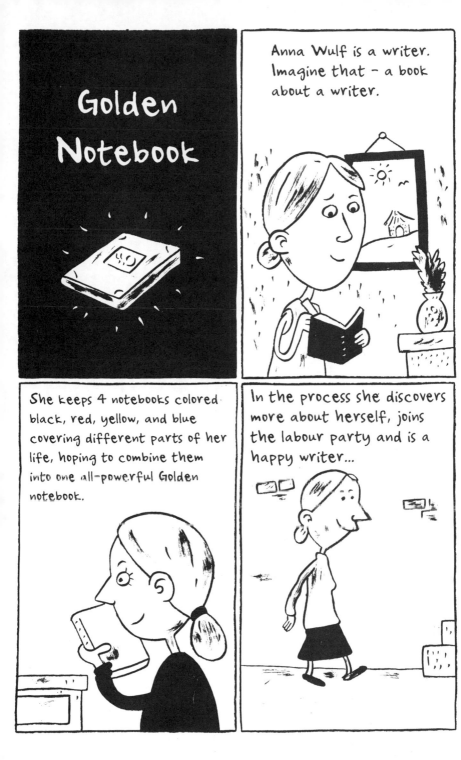

Golden Notebook

Anna Wulf is a writer. Imagine that — a book about a writer.

She keeps 4 notebooks colored black, red, yellow, and blue covering different parts of her life, hoping to combine them into one all-powerful Golden notebook.

In the process she discovers more about herself, joins the labour party and is a happy writer...

The Great Gatsby, 1925
F. Scott Fitzgerald, 1896-1940

The Great Gatsby

Nick spends the summer near **NYC** living next to a really rich guy named Gatsby.

Gatsby loves Nick's friend Daisy, Daisy is married to Tom, Tom is having an affair with the mechanic's wife, the mechanic is in love with Tom's car, and everyone loves the free drinks at Gatsby's.
But the mechanic's wife gets hit by a car.

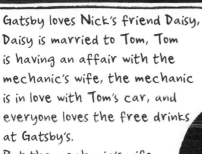

Gatsby gets shot in his pool by the mechanic and no one comes to his funeral including Daisy. Lesson: if you get really rich, forget your old relationships!

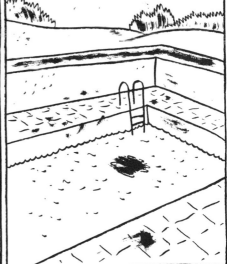

Gulliver's Travels, 1726
Jonathan Swift, 1667-1745

Gulliver's Travels

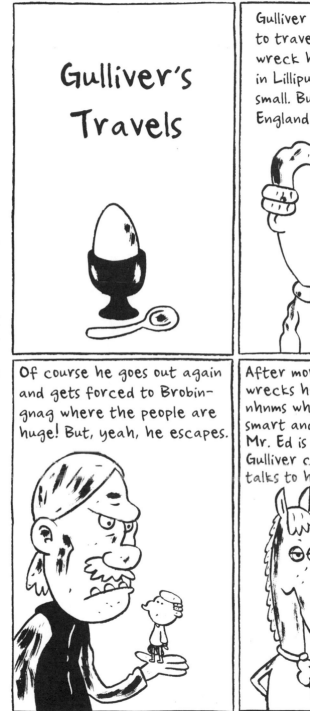

Gulliver is a guy that loves to travel. So after a shipwreck he is washed ashore in Lilliput where people are small. But he gets back to England **OK**.

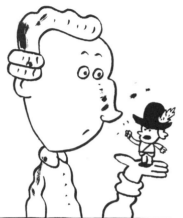

Of course he goes out again and gets forced to Brobingnag where the people are huge! But, yeah, he escapes.

After more travels and shipwrecks he goes to Houyhnhnms where the horses are smart and people terrible. Mr. Ed is from there. Gulliver comes back and talks to horses.

His family loves it.

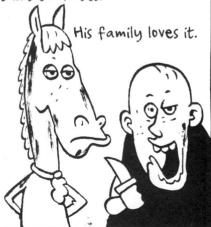

The Hitchhiker's Guide to the Galaxy, 1979
Douglas Adams, 1952-2001

The Hitchhiker's Guide to the Galaxy

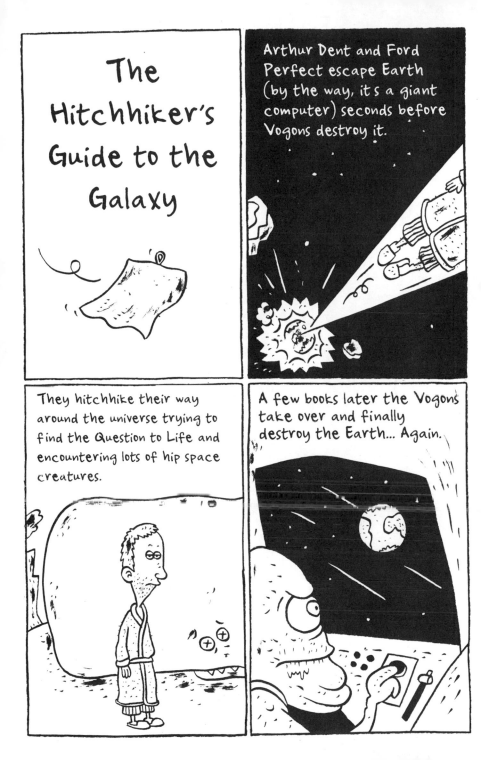

Arthur Dent and Ford Perfect escape Earth (by the way, it's a giant computer) seconds before Vogons destroy it.

They hitchhike their way around the universe trying to find the Question to Life and encountering lots of hip space creatures.

A few books later the Vogons take over and finally destroy the Earth... Again.

One Hundred Years of Solitude, 1967
Gabriel Garcia Márquez, 1927

One Hundred Years of Solitude

This book follows a family in the town Macondo starting with characters like Jose Arcadio who everyone thinks is crazy.

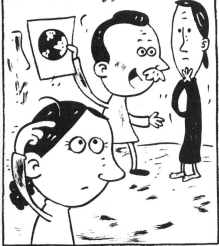

7 generations pass over these 100 years, everyone having the same names like Jose, Arcadio, Aureliano or all of the above.

In the 7th generation, baby Aureliano (See! I told you!) gets carried away by ants that were probably named Jose or Arcadio or...

I Am Legend, 1954
Richard Matheson, 1926-

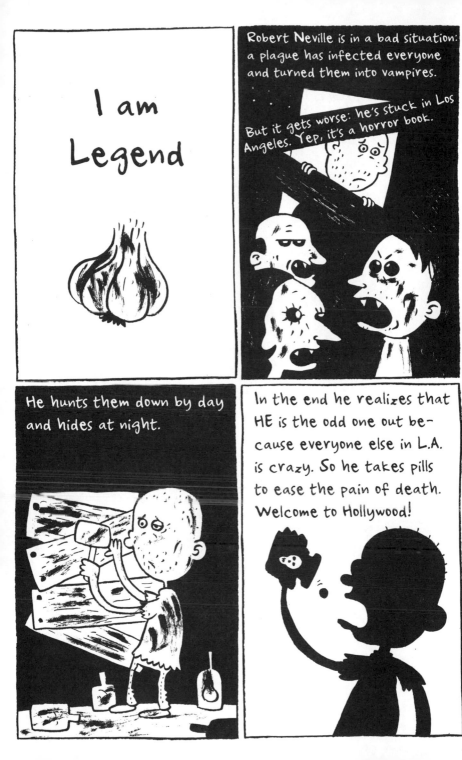

In Search of Lost Time, 1913-1927
Marcel Proust, 1871-1922

In Search of Lost Time

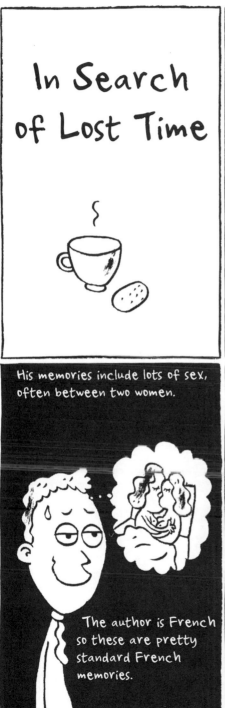

Marcel Proust wrote 1,000+ pages based on the memories that came when the narrator dips a madeleine into his tea.

His memories include lots of sex, often between two women.

The author is French so these are pretty standard French memories.

The memories unfold: people laugh, cry, sleep with each other and try to climb their way up society any way possible. The narrator, naturally, decides to write a novel in the end consisting of all the memories we just read about. Convenient.

The No. 1 Ladies Detective Agency, 1999
Alexander McCall Smith, 1948-

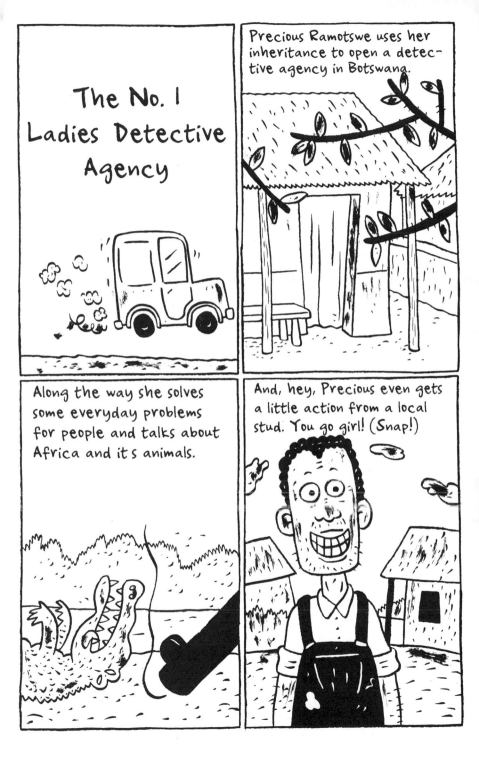

Perfume: The Story of a Murderer, 1985
Patrick S skind, 1949-

Perfume: The Story of Murder

Grenouille is a Frenchman that, ironically, has no natural scent but a gift for smell. People scorn him.

He grows into a driven young Frenchman that kills people to get their scent for perfumes.

Disgusted with himself, Grenouille puts on the greatest perfume ever and people tear him to pieces and eat him. It was even better than Drakaar Noir. Bitchin.

Pet Sematary, 1983
Stephen King, 1947-

Pet Sematary

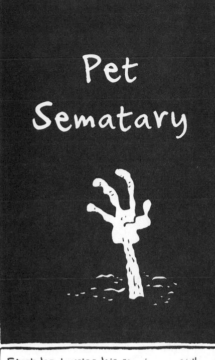

Louis is a man that has trouble dealing with loss.

First he buries his son in an evil cemetery that brings the dead back to life. Surprise! His son comes back evil and has to be killed.

Does he learn? No. He buries his wife there too and she comes back evil! Like Britney Spears evil. Louis needs to learn how to move on.

Darling...

The Piano Player, 1983
Elfriede Jelinek, 1946-

The Piano Player

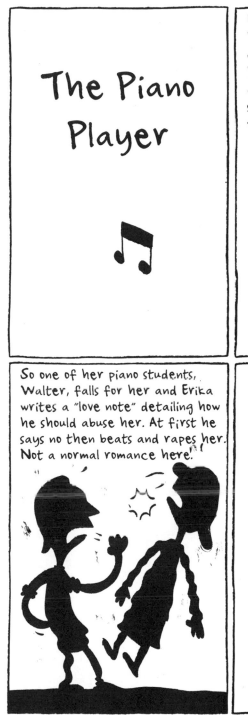

Erika Kohut is a woman that has some personal baggage. She teaches piano but lives at home with her dominating mom and Oh!, she also has extreme sadomasochistic desires. Yeah, there's that too.

So one of her piano students, Walter, falls for her and Erika writes a "love note" detailing how he should abuse her. At first he says no then beats and rapes her. Not a normal romance here.

Erika goes to the piano recital and sees Walter and what does she do? Stabs herself.

Because that is apparently what lovers not in therapy do.

The Shadow of the Wind, 2001
Carlos Ruiz Zafón, 1964–

The Shadow of the Wind

David is a young boy that gets a book from a secret library and becomes obsessed with it and the author.

He is followed by various people including the brutal Inspector Fumero. Maybe someone should've told him he could read a different book.

After much to-do the Inspector is killed and Daniel and the author can rest easy.

The Stranger, 1943
Albert Camus, 1913-1960

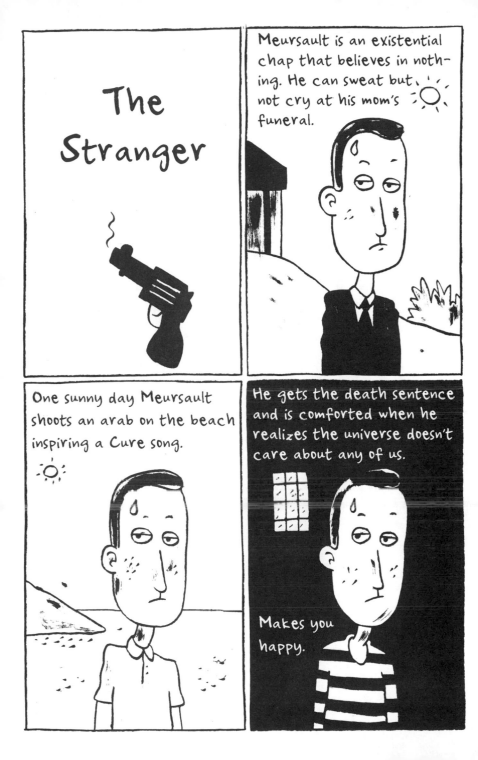

The Spy Who Came in from the Cold, 1963
John le Carré, 1931–

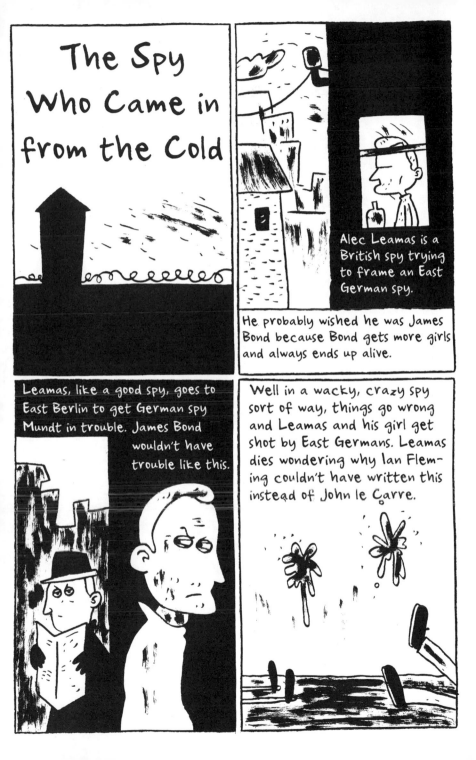

The Thorn Birds, 1977
Colleen McCullough, 1937–

The Thorn Birds

Meggie Clearly is a precocious young Aussie that falls in love with the local priest Ralph.

Like most obsessed people, Meggie stalks Ralph and finally consummates the relationship. Yep! The flesh is weak!

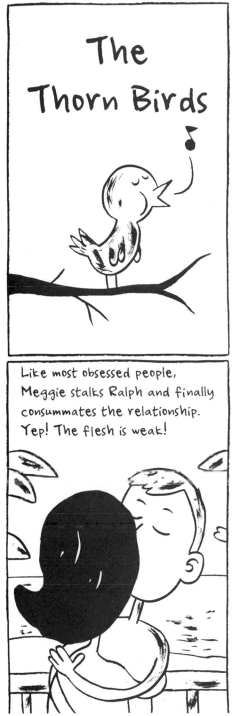

Ralph, now a cardinal, dies shortly after finding out Meggie's child is his. If Rome only knew. Wait! They probably do.

The Three Musketeers, 1844
Alexandre Dumas, 1802-1870

The Three Musketeers

d Artagnan heads to Paris with the dream of becoming a Musketeer. There he meets 3 already Musketeers and they become friends.

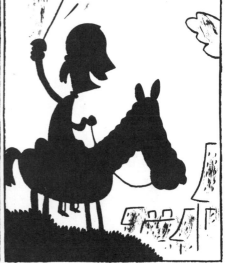

Of course there is a woman involved. This one is the criminal but gorgeous Milady can seemingly seduce any man. And throughout the story pretty much does.

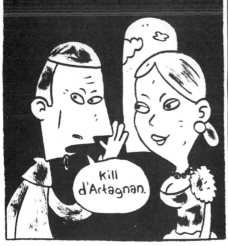

Kill d'Artagnan.

In the end Milady gets her head chopped off and d Artagnan becomes an official Musketeer.

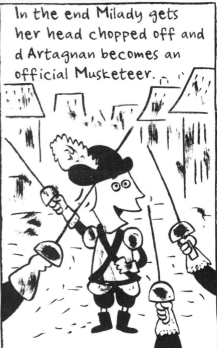

To Kill a Mockingbird, 1960
Harper Lee, 1926–

To Kill a Mockingbird

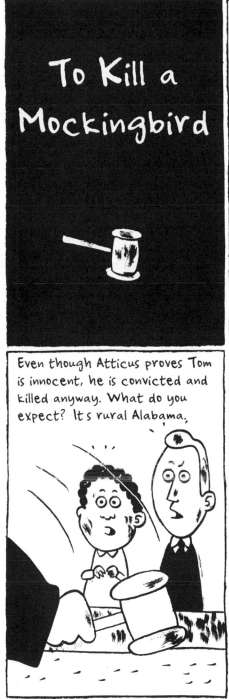

Atticus Finch is a southern law-yer that defends Tom Robinson: a black man falsely accused of raping a white woman.

Even though Atticus proves Tom is innocent, he is convicted and killed anyway. What do you expect? It's rural Alabama.

Atticus' children are attacked by the father of the raped girl but are saved by the creepy neighbor Boo Radley.
Another day south of the Mason-Dixon line.

Uncle Tom's Cabin, 1852
Harriet Beecher Stowe, 1811-1896

Uncle Tom's Cabin

Uncle Tom, a slave on a Kentucky farm, is sold off to another owner.

Eventually Tom ends up with a vicious plantation owner in Louisiana. Tom gets beat and whipped but still remains Christian.

His faith spreads as he forgives the white men that killed him and they change their ways.

The Da Vinci Code, 2003
Dan Brown, 1964-

The Da Vinci Code

After a murder in the Louvre, Robert Langdon is chased while trying to solve it; teaching us that museums are bad.

Robert and Sophie, who is trying to help him, are hunted by manic religious zealots while searching for the Holy Grail; teaching us that Opus Dei is bad.

In the end, they find out that Mary Magdalene is the Holy Grail and Sophie is a descendant of her and Jesus. The Catholic Church thinks this is bad.

Lord of the Rings, 1954 and 1955
J. R. R. Tolkien, 1892-1973

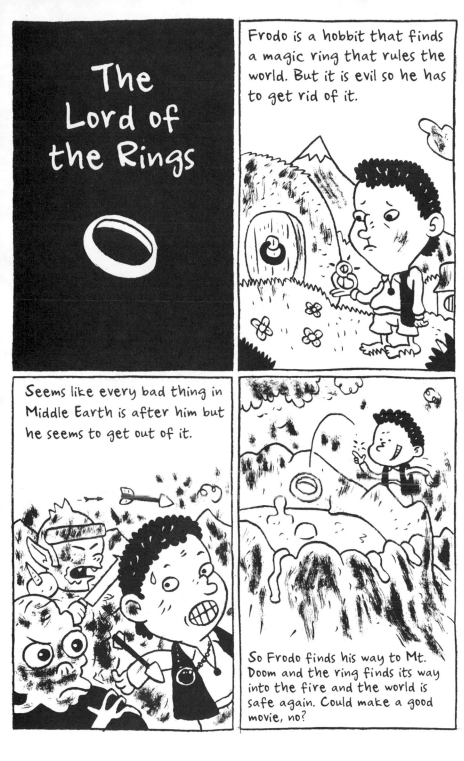

Heart of Darkness, 1899
Joseph Conrad, 1857-1924

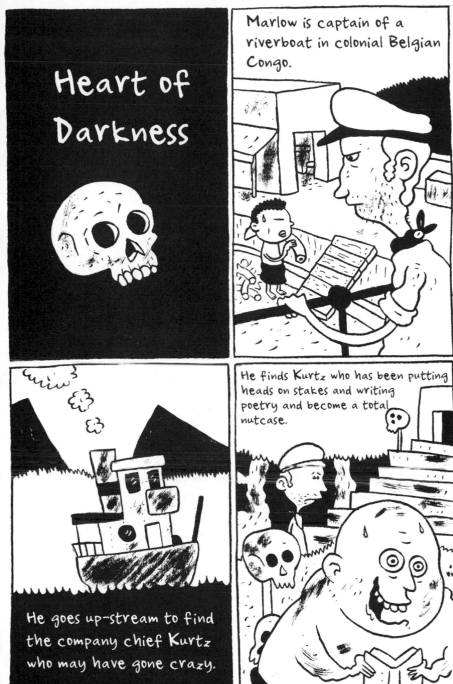

The Old Man and the Sea, 1952
Ernest Hemingway, 1899-1961

The Old Man and the Sea

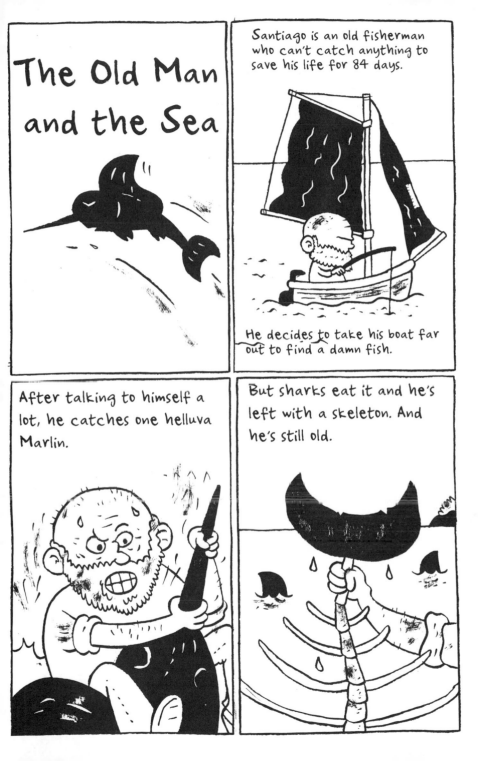

Santiago is an old fisherman who can't catch anything to save his life for 84 days.

He decides to take his boat far out to find a damn fish.

After talking to himself a lot, he catches one helluva Marlin.

But sharks eat it and he's left with a skeleton. And he's still old.

The Chronicles of Narnia: The Lion, the
Witch and the Wardrobe, 1950
C. S. Lewis, 1898-1963

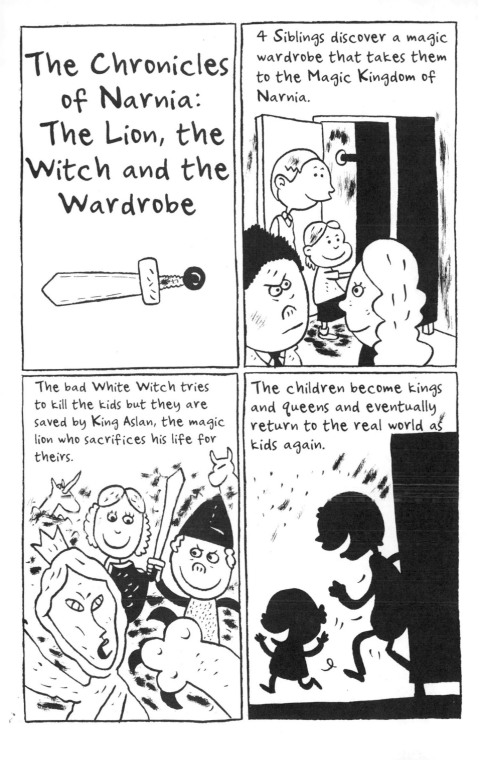

Lord of the Flies, 1954
William Golding, 1911-1993

Lord of the Flies

Ralph and Piggy (guess who is who) are stranded on an island with other boys after a plane crash.

They split into groups and a war breaks out. People die. This is the boy scouts gone bad.

So bad boy Jack sets the entire island on fire which gets a Navy ship to come to the rescue.

The officer says he would have expected better of British boys.

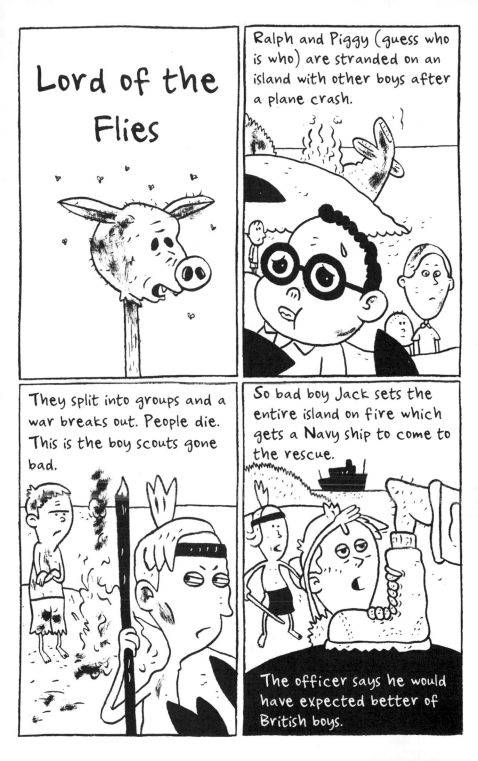

The War of the Worlds, 1898
H. G. Wells, 1866-1946

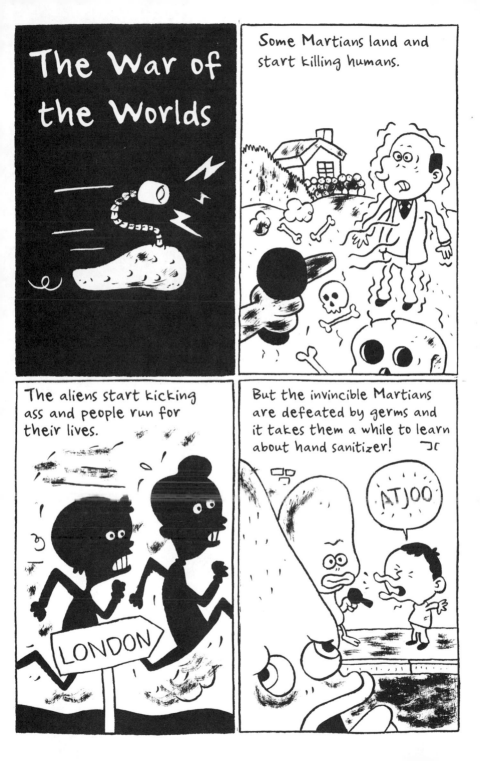

Nineteen Eighty-Four, 1949
George Orwell, 1903-1950

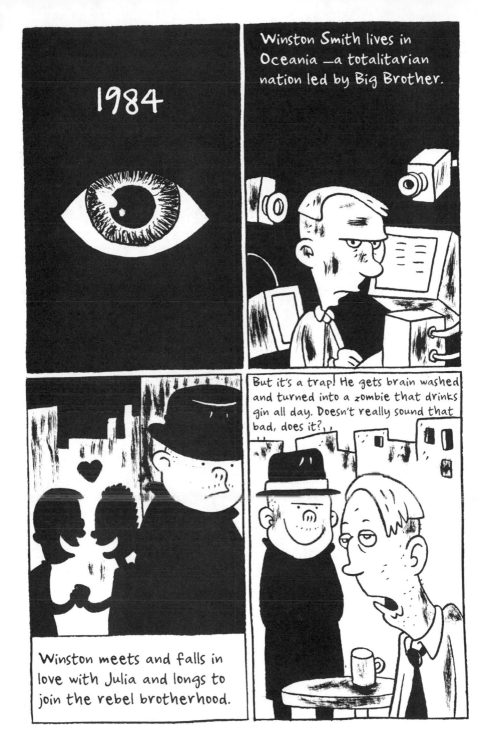

Moby-Dick, 1851
Herman Melville, 1819-1891

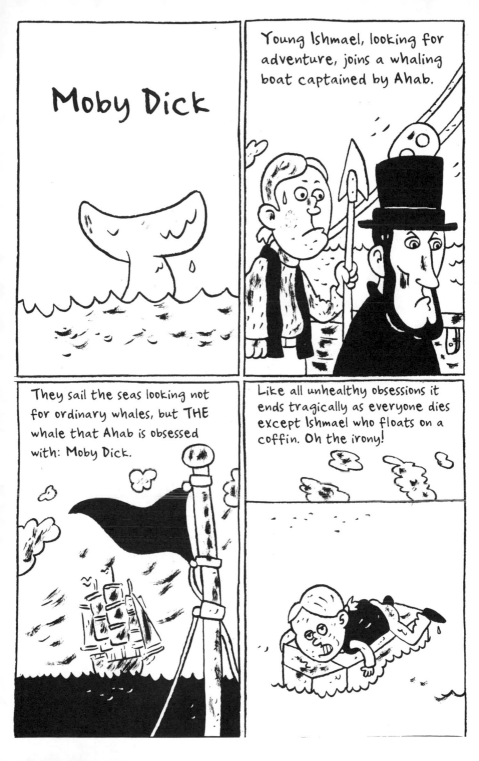

The Trial, 1925
Franz Kafka, 1883–1924

The Trial

§

Josef **K** is arrested on his birthday. We're not really sure why. Neither is he.

He goes through a labyrinth of legal processes which amount to nothing. If you've ever been on jury duty, you get the idea.

In the end, Josef **K** is killed, still not knowing why.

Score one for the legal system!

The Bible

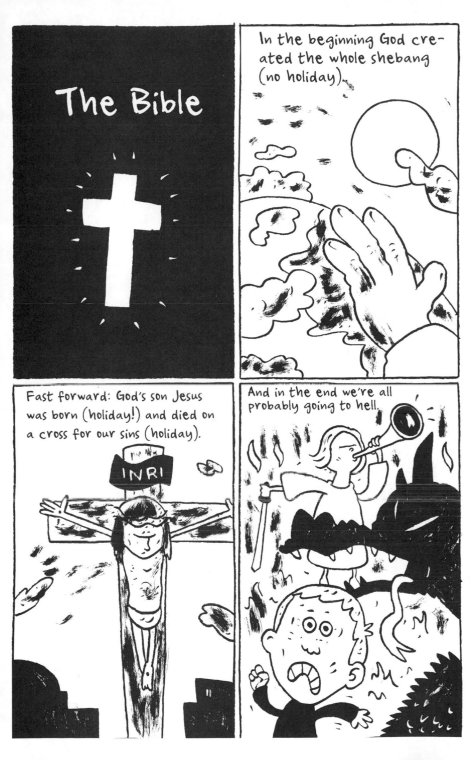

Crime and Punishment, 1866
Fyodor Dostoevsky, 1821-1881

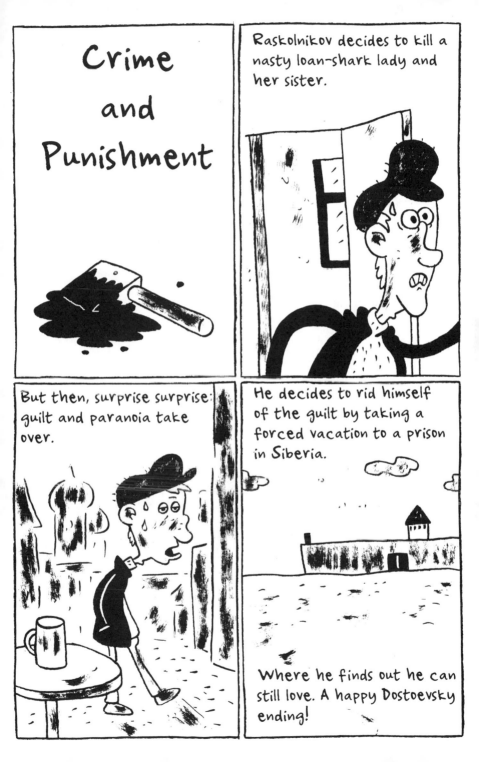

Crime and Punishment

Raskolnikov decides to kill a nasty loan-shark lady and her sister.

But then, surprise surprise: guilt and paranoia take over.

He decides to rid himself of the guilt by taking a forced vacation to a prison in Siberia.

Where he finds out he can still love. A happy Dostoevsky ending!

The Ingenious Hidalgo Don Quixote of La Mancha, 1605
Miguel de Cervantes, 1547-1616

The Ingenious Hidalgo Don Quixote of La Mancha

Don Quixote, in the days before TV, reads too much and gets crazy ideas.

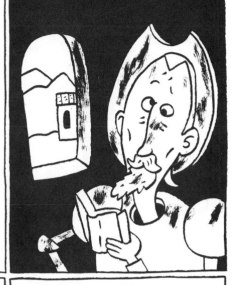

He attacks windmills that he thinks are giants and even his horse thinks he's nuts.

He discovers there is no room for heroes and goes home. The horse thanks God. So do the windmills.

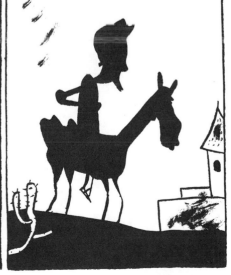

Twenty Thousand Leagues
Under the Sea, 1870
Jules Verne, 1828-1905

20,000 Leagues Under the Sea

Professor Arronax, a French scientist, leads an expedition to destroy a sea monster.

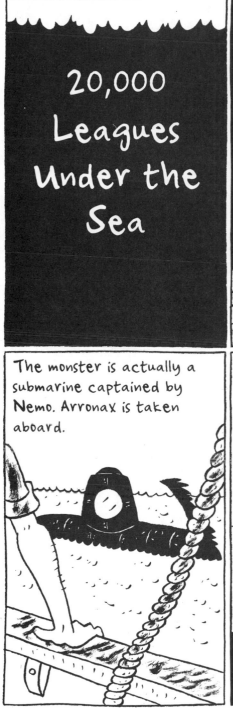

The monster is actually a submarine captained by Nemo. Arronax is taken aboard.

Arronax escapes with 2 other prisoners off the coast of Norway when the submarine is sucked into a whirlpool.

Treasure Island, 1883
Robert Louis Stevenson, 1850-1894

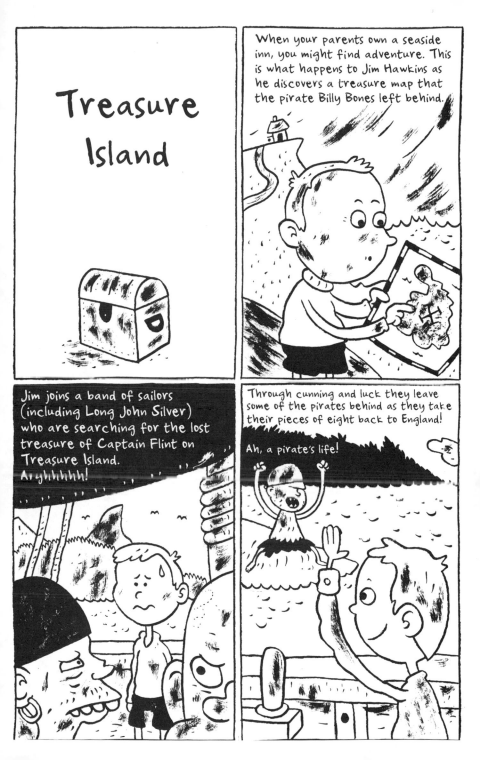

The Picture of Dorian Gray, 1890
Oscar Wilde, 1854-1900

The Picture of Dorian Gray

Dorian, a self-centered chap, gets a pretty portrait of himself. In this pre-botox era, he begs that the picture will turn old instead of him.

It works and after every act of debauchery the picture gets nastier. Dorian still looks young. Plastic surgery be damned!

The guilt makes him uneasy and he destroys the vile painting. He turns old, the picture turns young, and everyone in Los Angeles can learn from this.

The Adventures of Tom Sawyer, 1876
Mark Twain, 1835-1910

The Adventures of Tom Sawyer

WANTED

INDIAN JOE

Tom and his buddy Huckleberry Finn witness a murder by Injun Joe.

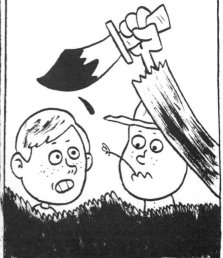

Tom decides to testify in court that Joe killed the man. Joe later corners Tom in a cave. This tells us that testifying in court can be bad.

But Tom escapes and gets Joe's hidden gold with Huck. They are heroes so maybe there is a payoff for doing your civic duty.

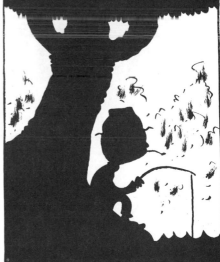

The Name of the Rose, 1980
Umberto Eco, 1932–

The Name of the Rose

Monk William of Baskerville goes to an Abbey where a murder has been committed.

Each day a monk dies including one drowned in a barrel of pigs' blood.

In the end the real killer is a book of comedy in the abbey's secret library.

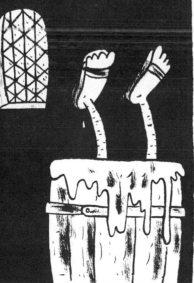

Don't worry.
This book won't do that.

Death in Venice, 1912
Thomas Mann, 1875-1955

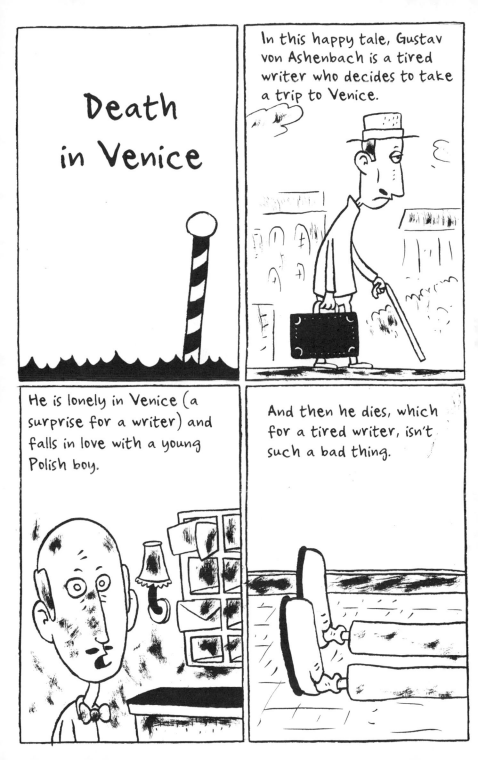

Lolita, 1955
Vladimir Nabokov, 1899-1977

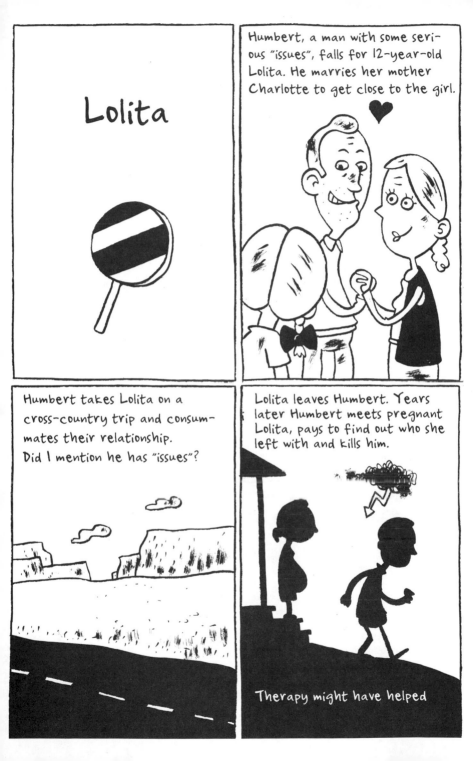

Catch-22, 1961
Joseph Heller, 1923–1999

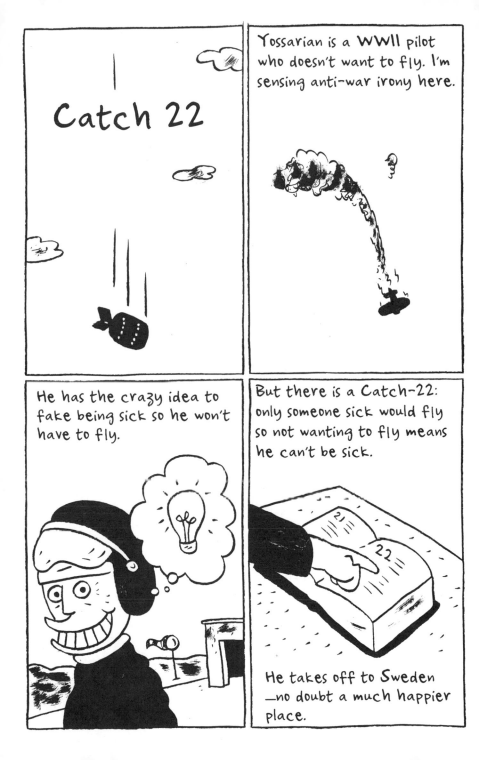

The Odyssey
Homer, ca. 8th century BC

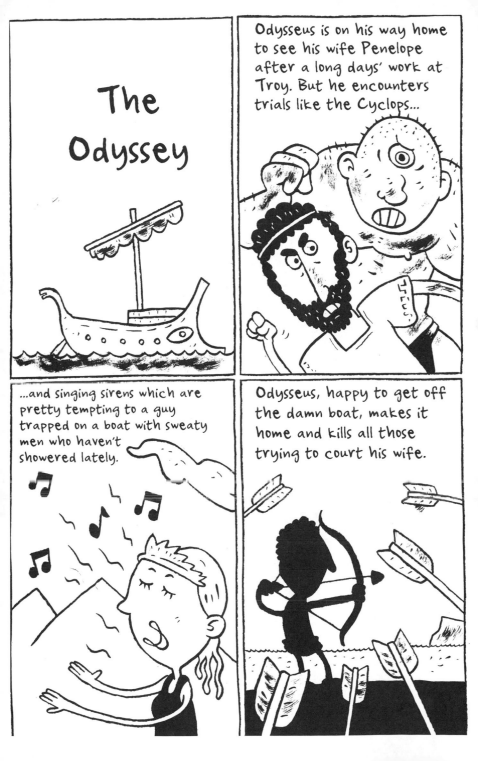

The Call of the Wild, 1903
Jack London, 1876-1916

The Call of the Wild

Buck is a dog that is taken from his hoity-toity life in California to be a sled dog in Alaska.

But he learns the ways of the wild and scores a cool owner in John Thorton.

Thorton is killed and Buck, fearing legal avenues won't be successful for a dog, goes 100% feral and lives in the wild.

Smilla's Sense of Snow, 1992
Peter Høeg, 1957–

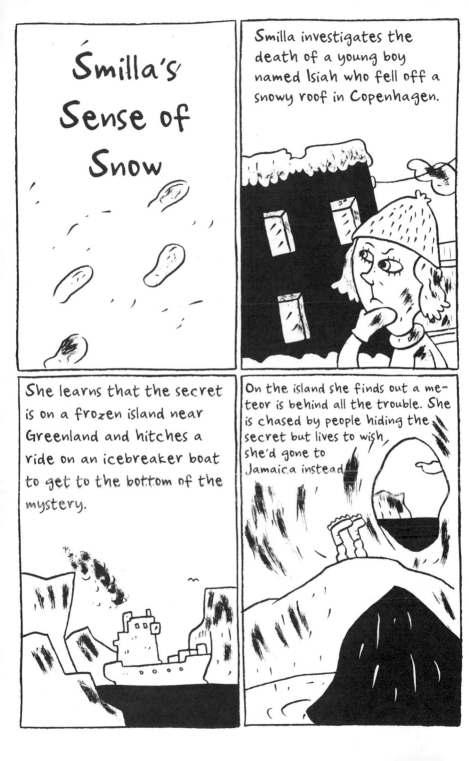

Smilla's Sense of Snow

Smilla investigates the death of a young boy named Isiah who fell off a snowy roof in Copenhagen.

She learns that the secret is on a frozen island near Greenland and hitches a ride on an icebreaker boat to get to the bottom of the mystery.

On the island she finds out a meteor is behind all the trouble. She is chased by people hiding the secret but lives to wish she'd gone to Jamaica instead.

Watership Down, 1972
Richard Adams, 1920-

Watership Down

A rabbit named Hazel learns of the destruction of his community's warren and convinces others to flee.

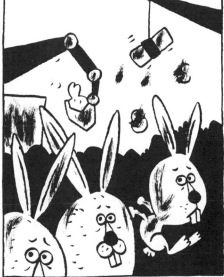

They go in search of a new home and encounter many hardships, the worst being that there aren't any females. Hello? They forgot the girls? They are rabbits, right?

The group eventually finds some girls. They form a happy community at Watership Down and live happily ever after.

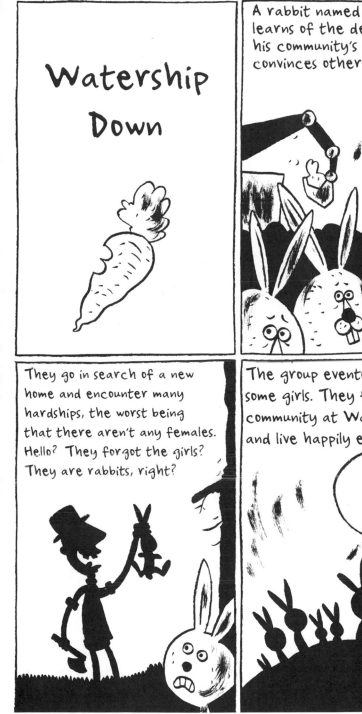

Life of Pi, 2001
Yann Martel, 1963–

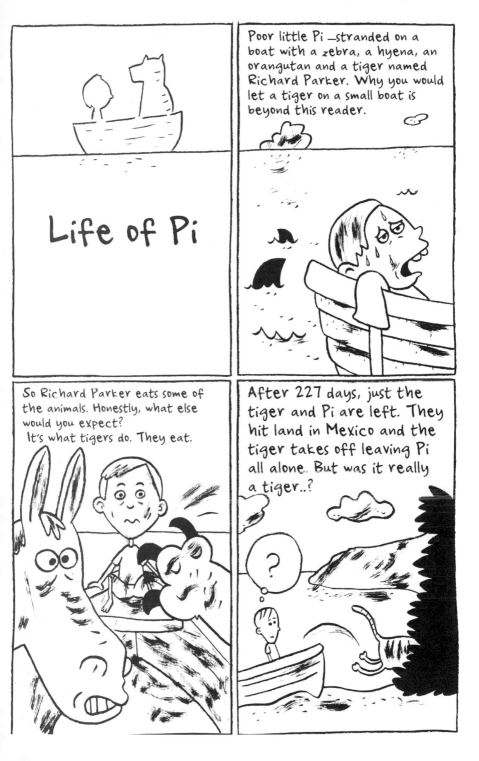

Naked Lunch, 1959
William S. Burroughs, 1914-1997

Naked Lunch

Agent William Lee is an exterminator and a good ol' junkie in search of a fix.

He spends lots of time and pages in the opium-induced Interzone where he parties with centipedes and experiences violent orgies.

Lee, just a lovable junkie, kills the police that are after him and goes on the run again. Note that the Opium Dealers Alliance does not support everything in this book and says drugs won't always make

centipedes party.

Alice's Adventures in Wonderland, 1865
Lewis Carroll, 1832–1898

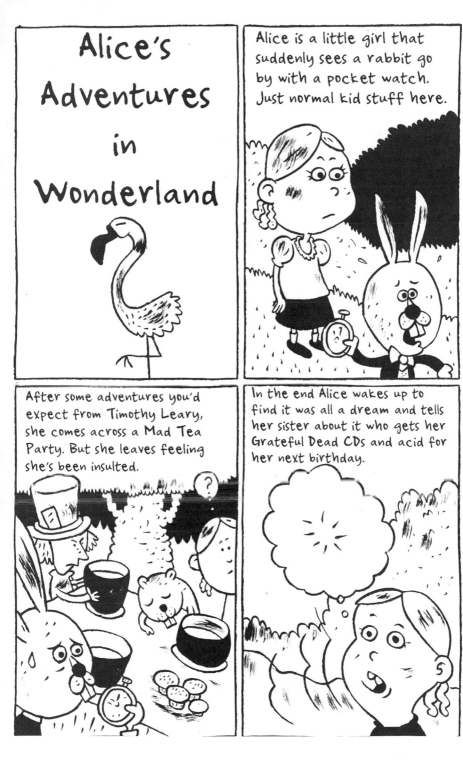

Nausea, 1938
Jean-Paul Sartre, 1905-1980

Nausea

Antoine basically does nothing except brood about the meaninglessness of life. It makes him nauseous. Angst.

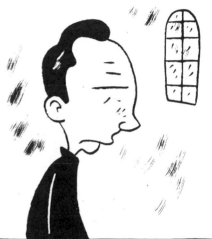

He has no job, no friends, hates the town and the history book he is writing, and his ex-girlfriend Anny wants nothing to do with him. Angst!

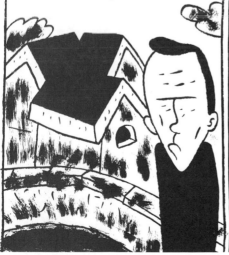

He thinks writing a novel will give his life some meaning. But it won't cover up the fact that he is a loser and will never have a girlfriend. ANGST!

Boule de Suif, 1884
Guy de Maupassant, 1850-1893

Boule
de Suif

A group flees the Franco/Prussian War with prostitute Boule de Sif.

She gives everyone food and becomes their best buddy. Who says friends can't be bought?

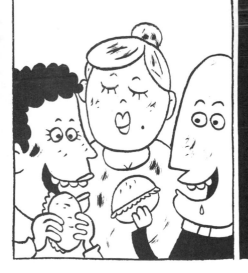

Boule is forced to sleep with a Prussian officer so they can escape, but everyone looks down on her.

Maybe she should feed them again?

And Then There Were None, 1939
Agatha Christie, 1890-1976

And Then There Were None

Ten people who are all murderers are called to Soldier Island. There they are accused of crimes they have not payed for.

They cannot get off the islad and they are all killed, one by one, not knowing who the killer is.

Everyone dies and the killer leaves a note confessing all the murders and that he commited suicide.

It was Judge Wargrave.

A Clockwork Orange, 1962
Anthony Burgess, 1917–1993

A CLOCKWORK ORANGE

Alex and his droogs go around beating people and drinking milk.

He goes into rehab under the Ludovico method where he is forced to listen to Beethoven whilst being shown scenes of violence.

When he gets out, violence and Beethoven sicken him. So people beat him up. Being nice doesn't pay.

The Hunchback of Notre Dame, 1831
Victor Hugo, 1802-1885

The Hunchback of Notre Dame

Esmeralda is wrongfully accused of murder and held in Notre Dame Cathedral by Archdeacon Claude Frollo who is obsessed with her.

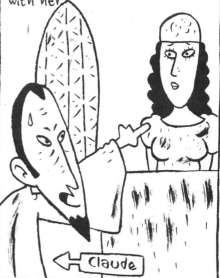

← Claude

Quasimodo, like every guy, falls for the beautiful Esmeralda and saves her from being executed.

In fact, love gets even sweeter when Quasimodo kills the evil Frollo for tormenting Esmeralda... and then disappears.

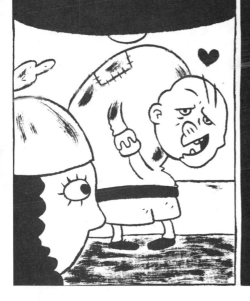

Claude

Three Men in a Boat, 1889
Jerome K. Jerome, 1859-1927

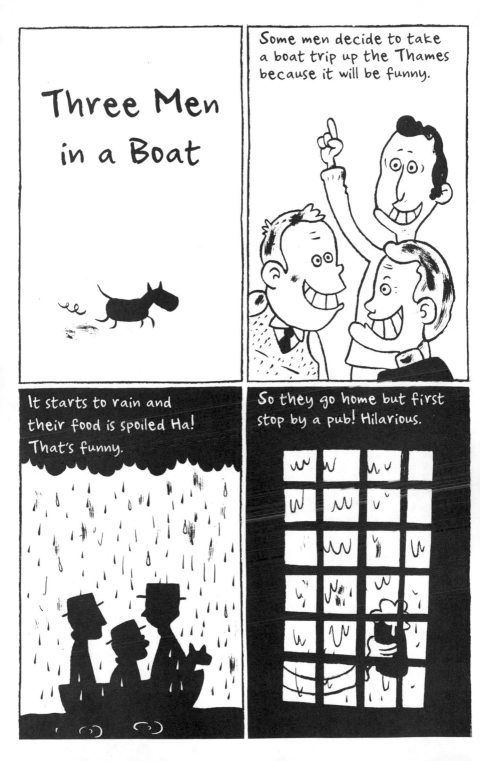

Of Mice and Men, 1937
John Steinbeck, 1902-1968

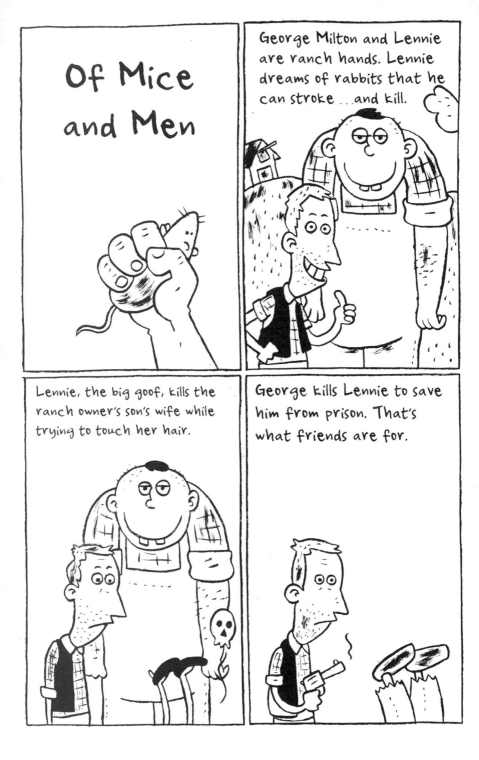

On the Road, 1957
Jack Kerouac, 1922-1969

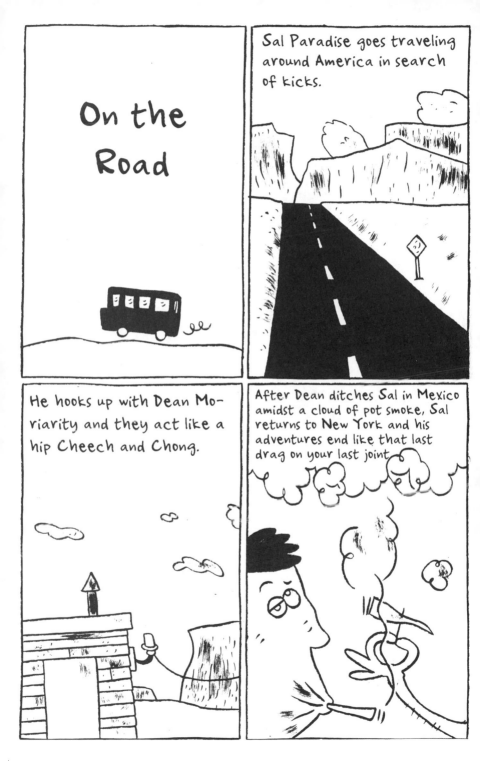

The Master and Margarita, 1928–1966
Mikhail Bulgakov, 1891–1940

The Master
and
Margarita

Magician Woland is Satan and visits Moscow to target the literary elite. He arrives with some strange company, like a fast-talking black cat who loves vodka and guns.

The Master is in prison for his book on Jesus. Margarita becomes a witch to save him and hosts the Devil's Ball.

Woland grants them peace but not salvation and then moves on.

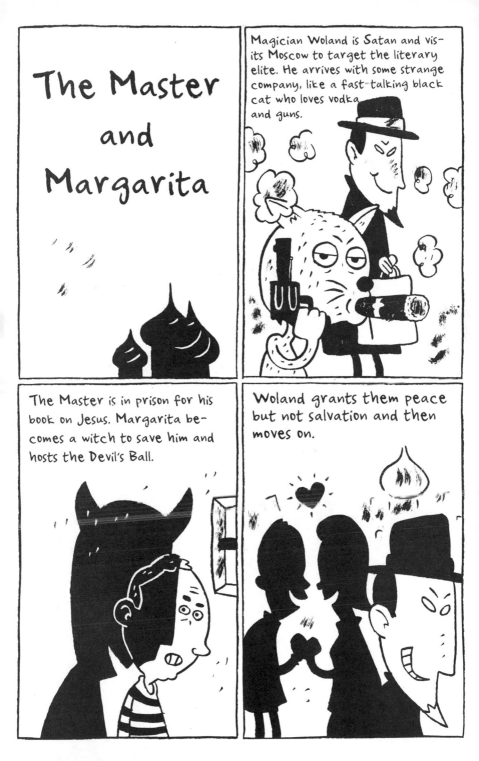

The Catcher in the Rye, 1951
J. D. Salinger, 1919–

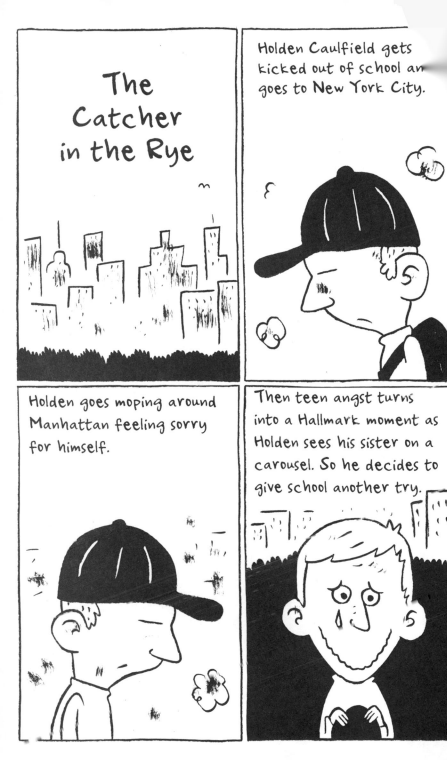

Ulysses, 1922
James Joyce, 1882–1941

Ulysses

Every day should begin with a good breakfast. So why not start one of the greatest books ever with Leopold Bloom and Stephen Dedalus eating their breakfasts in Dublin?

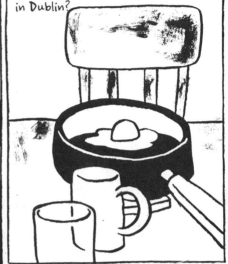

Leopold and Stephen eventually meet and drink like Irishmen all over the city. And there are about 800 pages of important prose too.

After they visit a brothel, Stephen leaves Leopold at home. Then Leopold's wife Molly ends the book forgetting how to use punctuation for like a million pages.

All Quiet on the Western Front, 1929
Erich Maria Remarque, 1898-1970

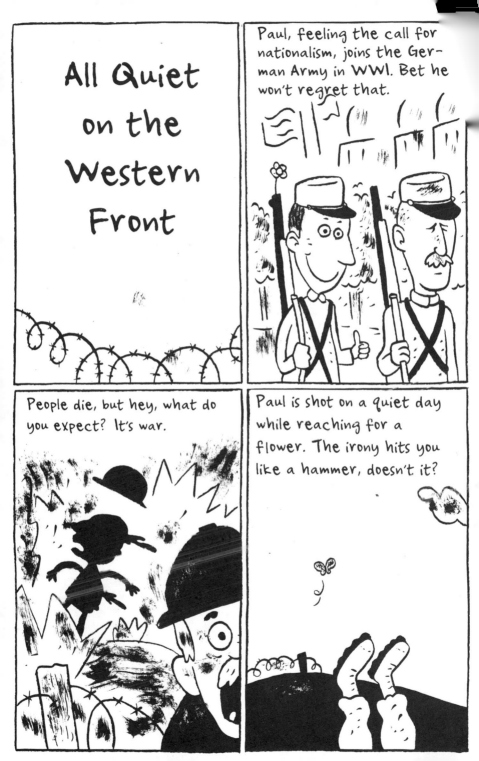

The Tell-Tale Heart, 1843
Edgar Allan Poe, 1809-1849

The Tell-Tale Heart

The Narrator decides t[o] kill the old man he lives with who has one clouded blue vulture eye.

He cuts him up neatly and hides him like a smart little homemaker under the floorboards: just like Martha Stewart would.

When the police come he hears the beating of the heart and goes mad and confesses. Lesson: if you commit a crime, always have an exit strategy.

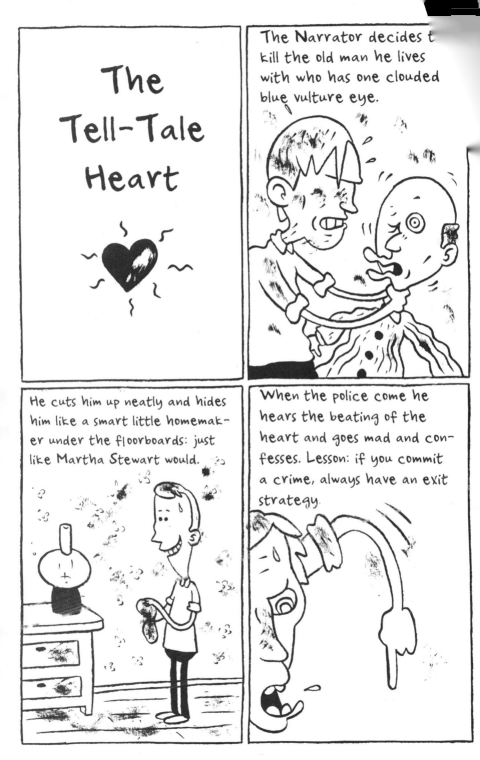

Das Boot, 1973
Lothar-Günther Buchheim, 1918-2007

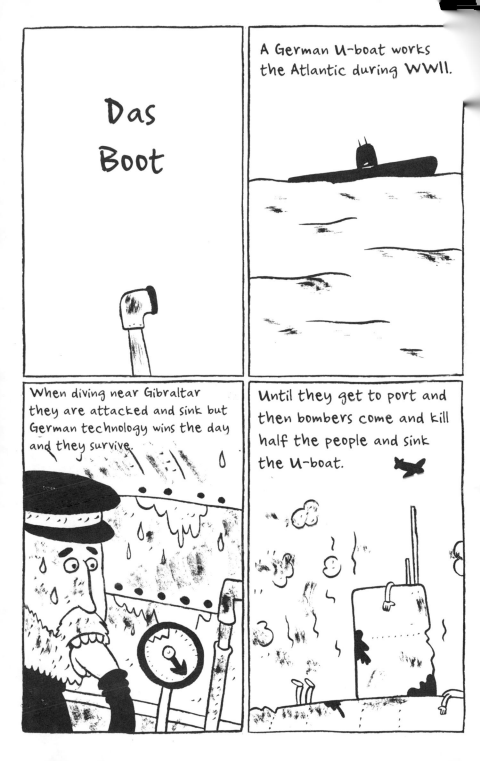

Watchmen, 1986-1987
Alan Moore, 1953-

One Flew Over the Cuckoo's Nest, 1962
Ken Kesey, 1935-2001

One Flew Over the Cuckoo's Nest

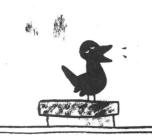

Randle McMurphy gets transferred from a prison to a psych hospital and the party begins.

McMurphy even gets the stuttering Billy Bibbit laid but Nurse Ratchard doesn't like it. She threathens to tell Billy's mom so he kills himself and McMurphy tries to strangle her.

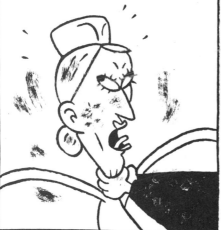

They give McMurphy a lobotomy and fellow patient Chief, the narrator, suffocates him out of pity and then escapes.

Thérèse Raquin, 1867
Émile Zola, 1840-1902

Thérèse Raquin

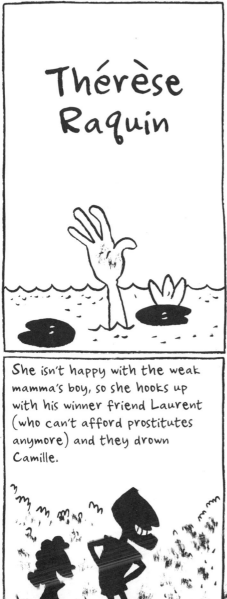

Therese is forced to mar[r]
her sickly cousin Camille.

She isn't happy with the weak mamma's boy, so she hooks up with his winner friend Laurent (who can't afford prostitutes anymore) and they drown Camille.

On the cheery side they are tormented by Camille's mom so after she dies they decide to kill each other. But they stop short and just commit suicide. Warm fuzzies indeed.

Our Man in Havana, 1958
Graham Greene, 1904-1991

Our Man
in Havana

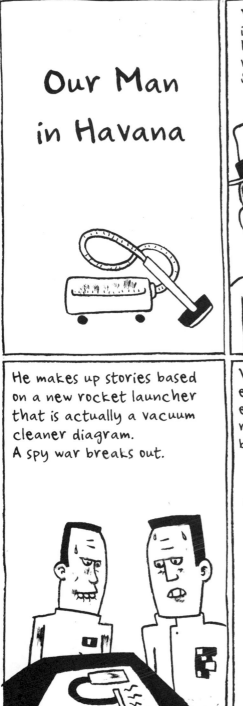

Wormold is a vacuum sale[...] in Havana with his daught[...] Milly. He accidentally gets recruited by the British Secret Service.

He makes up stories based on a new rocket launcher that is actually a vacuum cleaner diagram.
A spy war breaks out.

Wormold gets away, kills the enemy spy and the Brits are so embarrassed that they decorate him back in London. All because of vacuum cleaners.

Charlie and the Chocolate Factory, 1964
Roald Dahl, 1916-1990

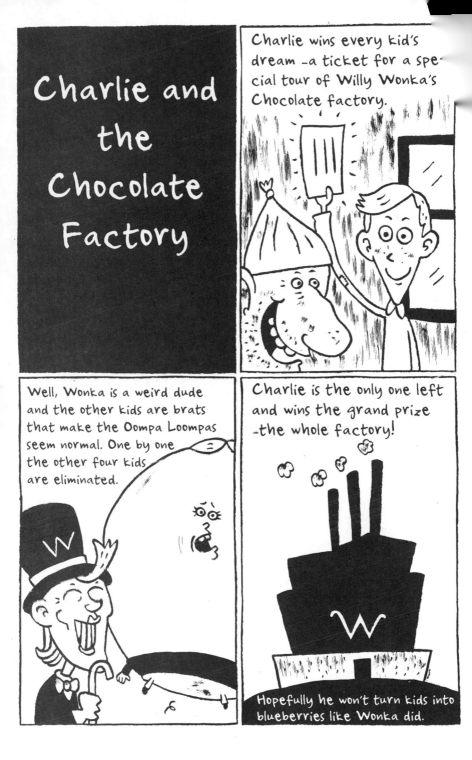

Charlie and the Chocolate Factory

Charlie wins every kid's dream –a ticket for a special tour of Willy Wonka's Chocolate factory.

Well, Wonka is a weird dude and the other kids are brats that make the Oompa Loompas seem normal. One by one the other four kids are eliminated.

Charlie is the only one left and wins the grand prize –the whole factory!

Hopefully he won't turn kids into blueberries like Wonka did.

Romeo and Juliet, 1597
William Shakespeare, 1564-1616

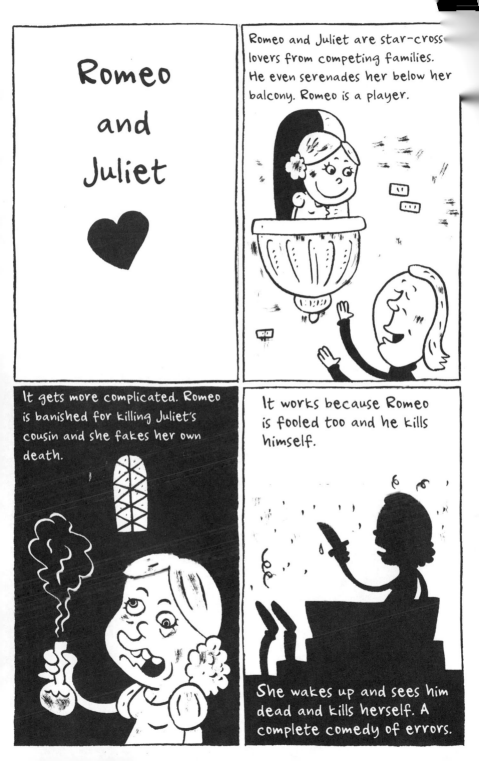

Frankenstein, 1818
Mary Shelley, 1797-1851

Frankenstein

Scientist Frankenstein plays God and creates "the Creature" who is made of different body parts. Kind of like a casserole made with left-overs

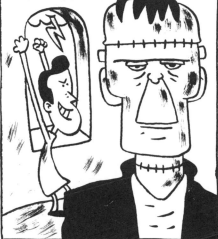

The Creature, with understandably low self-esteem, starts killing people close to Frankenstein out of revenge.

Frankenstein chases the Creature but loses him in the North Pole, dies, and then the Creature kills himself.

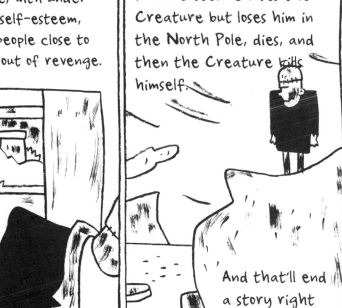

And that'll end a story right there.

Robinson Crusoe, 1719
Daniel Defoe, 1659 / 1661-1731

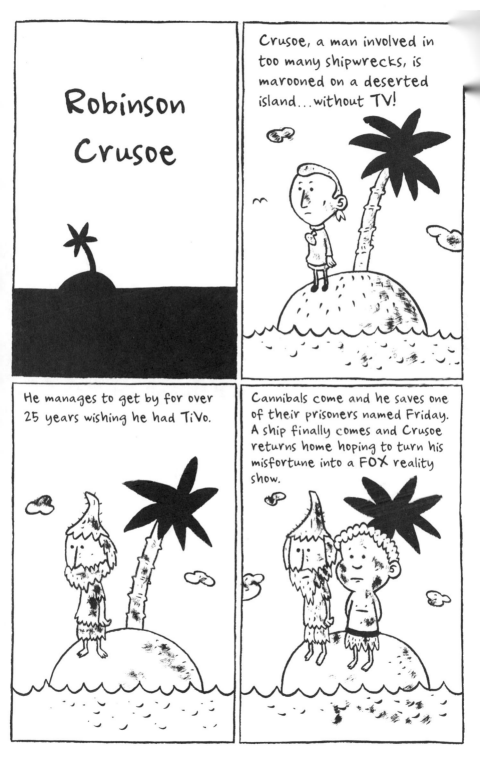

The Hound of the Baskervilles, 1901-1902
Arthur Conan Doyle, 1859-1930

the Hound of the Baskervilles

Sherlock Holmes is summoned when Charles Baskerville is found dead due to a hideous hound.

Everyone is a suspect! Who can you trust? No one when you are Sherlock Holmes. Including that rascal Stapleton.

Even a British fog can't stop Holmes as he discovers Stapleton was the killer going after Baskerville's money using a deformed hound. PETA probably would've killed Stapleton anyway.

Steppenwolf, 1928
Hermann Hesse, 1877-1962

Steppenwolf

Harry Haller is a writer who (now here's a shocker) doesn't fit in. He reads about a lone wolf and decides to take his own life.

Harry meets Hermine at a dance and she begins to teach him how to live.

Later at a masquerade ball, Harry kills Hermine and discovers that life is what it is. And he is still sullen.

SIGH

Factotum, 1975
Charles Bukowski, 1920-1994

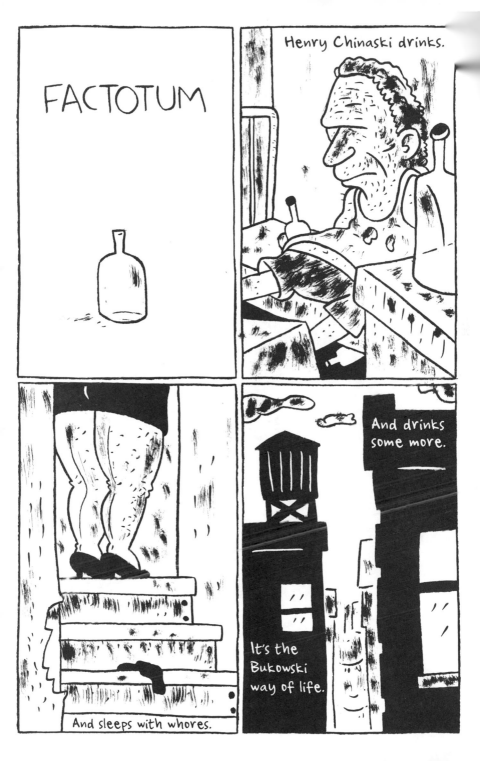

Pride and Prejudice, 1813
Jane Austen, 1775-1817

Pride
and
Prejudice

Trouble brews when wealth young English bachelors, Bingley and Darcy, move into the village of Meryton.

Darcy proposes to Elizabeth and she refuses because he is a pompous English ass.

But Elizabeth discovers that Darcy isn't such a bad guy and agrees to marry him. And a whole genre is started to give Hugh Grant work!

The Naked and the Dead, 1948
Norman Mailer, 1923-2007

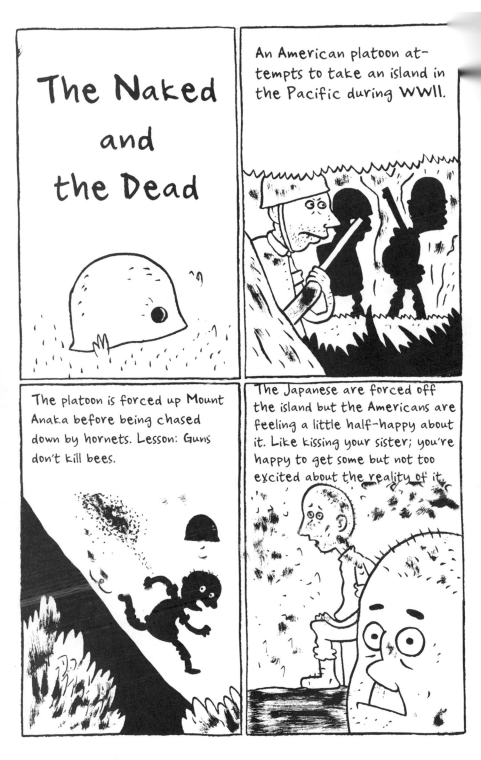

The Naked and the Dead

An American platoon attempts to take an island in the Pacific during WWII.

The platoon is forced up Mount Anaka before being chased down by hornets. Lesson: Guns don't kill bees.

The Japanese are forced off the island but the Americans are feeling a little half-happy about it. Like kissing your sister; you're happy to get some but not too excited about the reality of it.

2001: A Space Odyssey, 1968
Arthur C. Clarke, 1917-2008

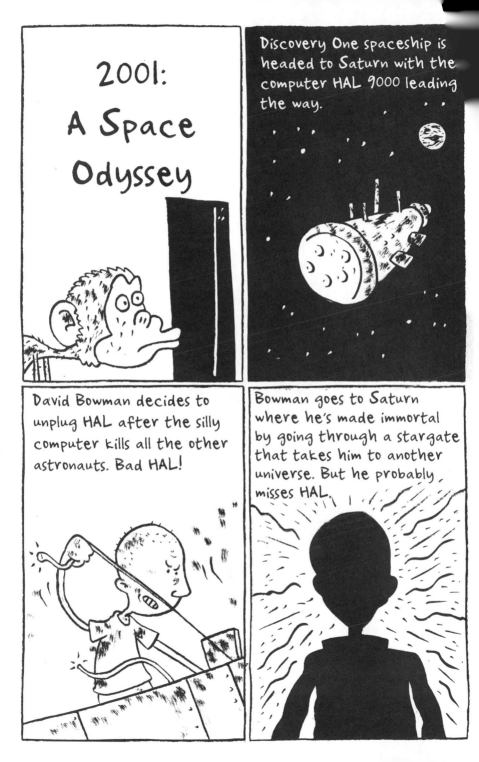

Oliver Twist, 1839
Charles Dickens, 1812-1870

Oliver Twist

Oliver, an orphan in England, is recruited by the criminal Fagin.

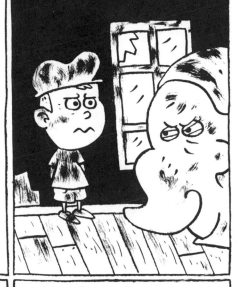

He is faced with a life of crime with Fagin, being destroyed by half-brother Monks and his friend Nancy gets murdered. It's tough being a Dickens orphan, isn't it?

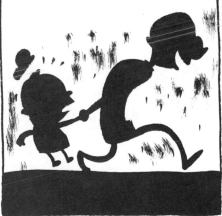

Or is it? Mr. Brownlow takes in Oliver to a happy life in the country. Warm fuzzies here at last!

Hunger, 1890
Knut Hamsun, 1859-1952

Hunger

Our narrator is a hungry young man. He tries to make it as a writer but never thinks of getting a job.

He meets Ylajali and falls for her. But he's still damned hungry and soon she dumps him. A paycheck might help.

So he leaves town on a ship as a crew member. Miracle of miracles, he finally gets a job.

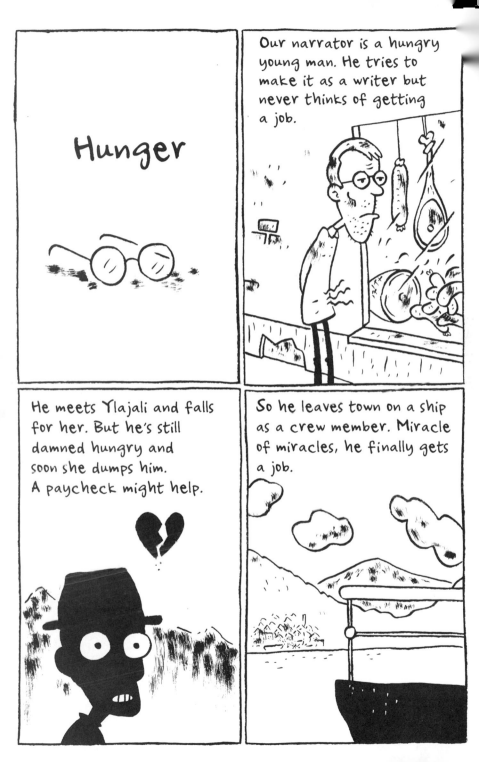

The Alchemist, 1988
Paulo Coelho, 1947–

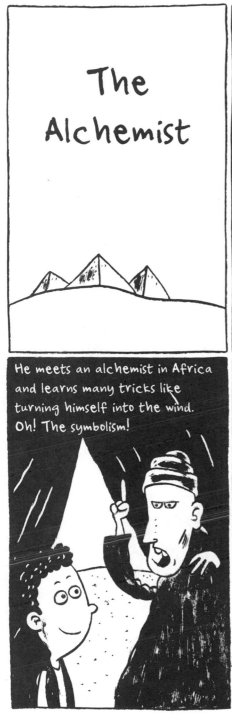

The Alchemist

Santiago, a shepherd in Spain, has a dream he will find treasure in the pyramids.

He meets an alchemist in Africa and learns many tricks like turning himself into the wind. Oh! The symbolism!

He finds out after getting beat-up near the pyramids that the treasure is really back home. So he gets his riches in the end.
Good for him.